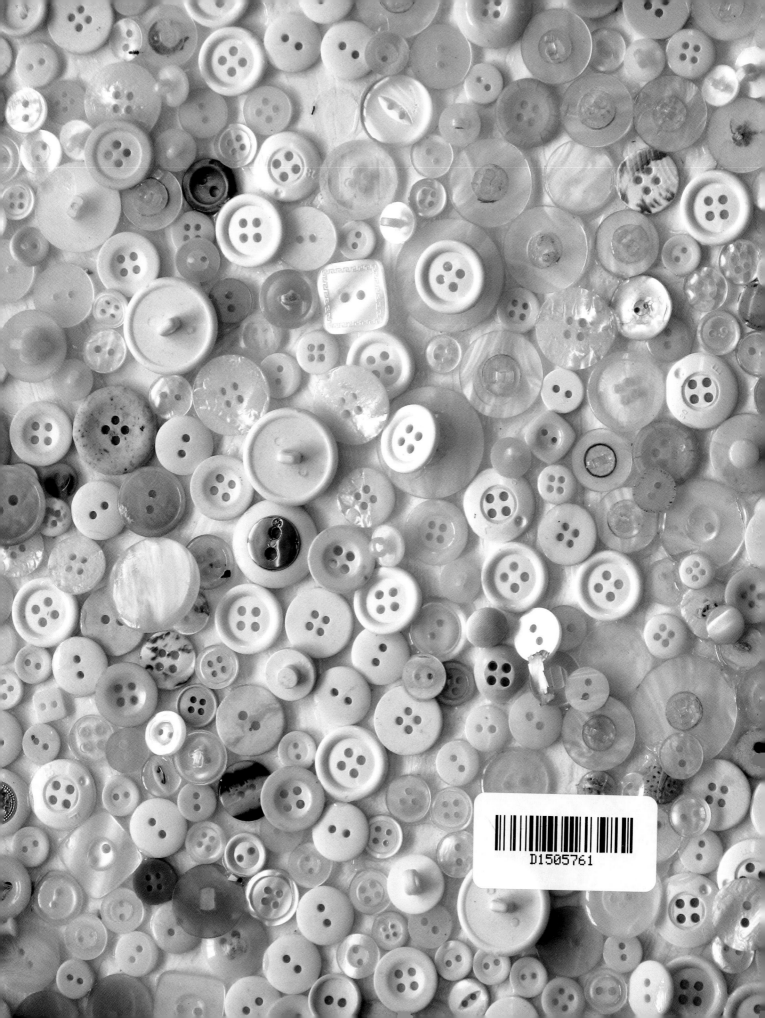

For The Art Room students

PICTURE ACKNOWLEDGEMENTS
Page 16: *Portrait of Elias Ashmole* by John Riley, © Ashmolean Museum,
University of Oxford/The Bridgeman Art Library
Page 18: *Le Chant des Fleurs* by Pablo Picasso, © Succession Picasso/DACS 2009
Page 22: Statement Chair designed by Marti Guixe, Exhibition in Spazio Lima,
Milan 2004. Photo © Imagekontainer
Page 28: *River Scene with Rainbow: ?Near Isleworth* (1805) by J.M.W. Turner,
© Tate, London 2009
Page 30: Round Plate: *Face* by Pablo Picasso, © Succession Picasso/DACS 2009

The Art Room copyright © Frances Lincoln Limited 2010
Text copyright © The Art Room 2010
Illustrations copyright © The Art Room 2010
Photographs by Brian Peart of Chromatech

First published in Great Britain and the USA in 2010 by
Frances Lincoln Children's Books, 4 Torriano Mews,
Torriano Avenue, London NW5 2RZ
www.franceslincoln.com

The authors would like to thank the inspirational students and staff of The Art Room,
both past and present, for their dedication, hard work and tremendous talent,
Reya, Isobel, Hashim, Aman, Laurel, Salim, Leon, Cottia, Ele, Ellie and Will for their team spirit,
and Marshall Buttons and Trimmings for their endless supplies of little round fasteners.

British Library Cataloguing in Publication Data available on request

ISBN: 978-1-84507-971-0

Set in The Sans and Rosewood

Printed in Shenzhen, Guangdong, China by C&C Offset Printing in March 2010

1 3 5 7 9 8 6 4 2

THE ART ROOM

Turn everyday things into works of art

Juli Beattie • Arabella Warner

F

FRANCES LINCOLN
CHILDREN'S BOOKS

in association with

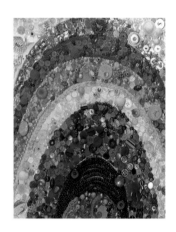
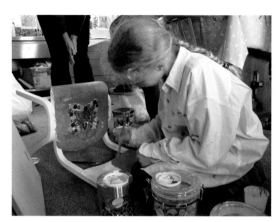

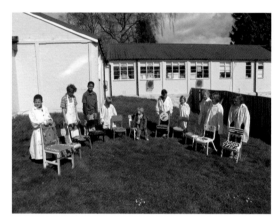
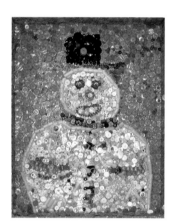
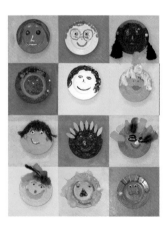
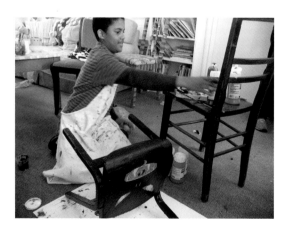

FOREWORD

This book brings to a much wider audience the innovative and exciting ideas used in The Art Room, a charity that uses art to give children ever-expanding opportunities for new expression and experience.

I have been lucky enough to have been involved with The Art Room for many years and am delighted to be able to recommend this book. I remember arriving at The Art Room one morning to see three beautifully decorated wooden chairs. One child had covered every inch of the chair with the names of her friends, another had attached a pair of butterfly wings to the back, and the third was painted in the colours of a favourite football team. It seemed to me that being given something firm as a solid foundation instilled in these children the self-confidence to express their own creativity.

Turn the pages, and choose from the wonderfully tactile lists of materials, from buttons and beads to corks and cotton-reels. I know you will find in the warm, welcoming and colourful world that is The Art Room projects that will give you enormous satisfaction and enjoyment.

And share it with all your friends. I know I will.

Jon Snow
Broadcaster

CONTENTS

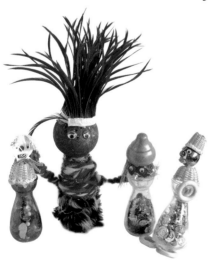

INTRODUCTION

The projects in this book are the result of many years of work with children at The Art Room, a charity offering young people the chance to learn and achieve through art.

We aim to tap into the innate creativity of every child by showing how satisfying it is to transform ordinary objects into works of art.

Each project is inspired by the everyday items that you can find around the home, in junk shops and car boot sales. It really is amazing how you can create something unique out of the cheapest of materials.

So have a go – on your own or with others, and let your imagination fly.

Juli Arabella

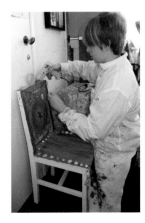 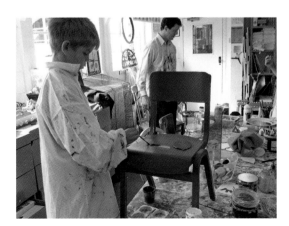

BASIC EQUIPMENT

- ✔ Good quality scissors
- ✔ Glue (craft glue, glue stick and glue guns are useful but must be supervised by an adult)
- ✔ Paper
- ✔ Paint and brushes
- ✔ Glitter
- ✔ Sellotape/Scotch tape
- ✔ Masking tape
- ✔ Pencils, crayons and felt-tip pens
- ✔ Paper bags
- ✔ Post-it stickers
- ✔ Envelopes
- ✔ Self-adhesive stickers

HOW TO STAY ORGANISED

✔ Keep the area clean as you go along.

✔ Remember to recycle all the time.

✔ Wear a protective shirt and apron – use old white shirts, aprons and overalls from second-hand shops.

✔ Use plastic tablecloths, old sheets or duvet covers to protect your working area.

✔ Save margarine tubs with lids, plastic takeaway trays, jam jars, ice cream cartons, and biscuit tins in which to put materials.

✔ Label everything.

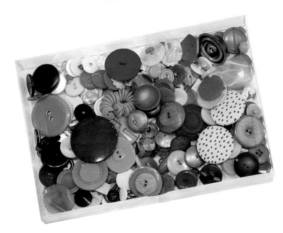

USEFUL MATERIALS TO COLLECT

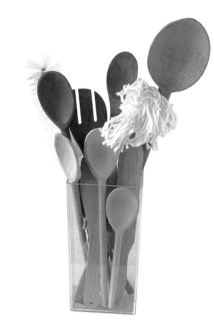

- ✔ Beads
- ✔ Bits and bobs such as unwanted tiddlywinks, lego bricks and small plastic toys
- ✔ Bottle-tops (plastic, not metal)
- ✔ Buttons
- ✔ Buckles
- ✔ Christmas decorations
- ✔ Corks
- ✔ Cotton reels/spools
- ✔ Fabric
- ✔ Feathers
- ✔ Gemstones
- ✔ Gold and silver anything
- ✔ Old broken jewellery
- ✔ Old CDs
- ✔ Pebbles
- ✔ Pipe cleaners
- ✔ Plastic bottles
- ✔ Plastic flowers
- ✔ Ribbons and trimmings
- ✔ Shells
- ✔ Stamps
- ✔ String and wool
- ✔ Sweet/candy wrappers

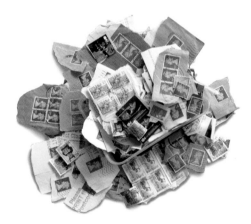

GOOD PLACES TO FIND MATERIALS

- ✔ Charity shops/thrift stores: you will often make great finds here.
- ✔ Jumble sales, secondhand shops, junk shops: these can be a good source of plain white china plates, picture frames, old mirrors, chairs and other furniture.
- ✔ Local community: Look out for shop clearance sales where you will find unwanted, end-of-line products. Don't be afraid to ask at builders' merchants and printers for surplus materials. Ask shoe shops for shoe boxes and restaurants for corks.
- ✔ Local recycling and scrap stores.
- ✔ Discount shops.

USEFUL WEBSITES

http://www.freecycle.org
http://www.recyclezone.org.uk
http://www.nationalgallery.org.uk
http://www.vam.ac.uk
http://www.britishmuseum.org
http://www.moma.org
http://artic.edu
http://nga.gov

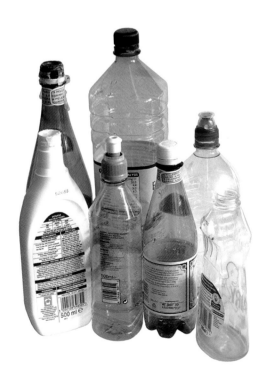

BUTTON SNOWMAN

Don't you just love old buttons? Sifting through a box filled with buttons of all shapes, sizes and textures is a wonderful experience. Where did they come from? How were they used? Who wore them? Each button has a story to tell. Buttons also make great mosaic tiles.

You will need lots of buttons to make this snowman, so you may need to ask friends and family to help you collect enough. See who can find the biggest, the smallest, the softest or the strangest button. Then sort them by colour.

A snowman is fun, but you can choose any simple shape to make.

YOU WILL NEED:

- ✔ Large box or piece of wood – ours was 1.5m by 1.2m (5ft by 4ft)
- ✔ White, yellow, pink and black buttons (or whatever colours you can lay your hands on)
- ✔ Craft glue

INSTRUCTIONS:

1. Draw the basic shape of the snowman on the plain wood with a felt-tipped pen. You could draw around 2 plates, one small and one large, to form the head and body. Add a hat, buttons, scarf, eyes, nose and a mouth. This is the basic pattern to build on.
2. Glue on the pink and white buttons using the pink buttons as the background.
3. Pick out details such as eyes and hands using contrasting colours.

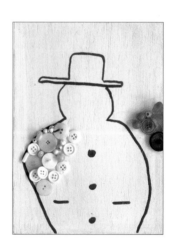

- During World War 2, some Royal Air Force buttons were made with a secret compass hidden inside.
- King Francis 1 of France owned a coat sewn with 1,000 gold buttons!

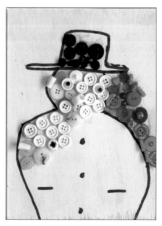

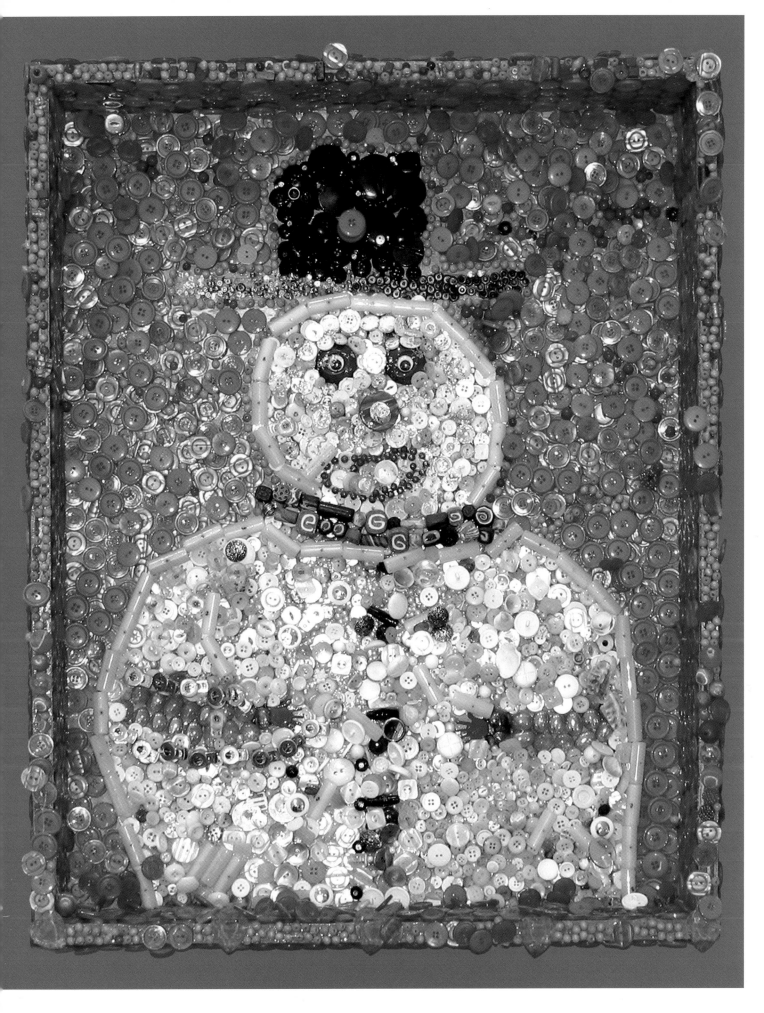

JUNK FRAMES

This amazing frame surrounding the portrait of Elias Ashmole, founder of The Ashmolean Museum in Oxford, was crafted from limewood by Grinling Gibbons. Our frame was bought in a charity shop/thrift store, decorated with recycled items, then sprayed gold.

Decorated frames for pictures, photos and mirrors make wonderful presents and look great up on the wall. Make your own using old frames, recycled shoeboxes or cheap frames from discount shops.

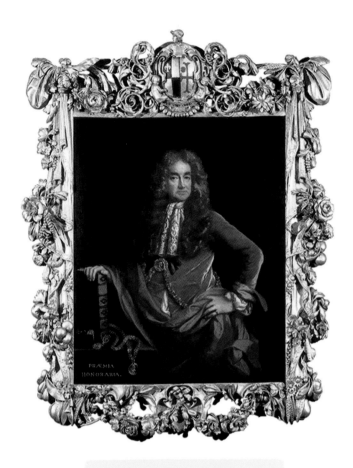

YOU WILL NEED:

- ✔ A shoebox/shoebox lid or a box bigger than the photograph or picture you are framing
- ✔ Glue
- ✔ Shells, feathers, twigs and leaves
- ✔ Artificial flowers
- ✔ Ribbons, buttons and corks
- ✔ Unwanted small items such as small plastic toys, bottletops and used crayons
- ✔ Gold and silver spray paint (only to be used by an adult)

Grinling Gibbons was famous for including a carved pea-pod in every frame he made.

INSTRUCTIONS:

1. Stick the photograph or picture on the front of the box in the position you would like it to be.
2. Decorate with glitter, shells, feathers or buttons, or stick on corks, bottle-tops, crayons, unwanted key-rings, buckles, even Christmas decorations – then spray with gold or silver paint.
3. Fix ribbon or string on the back and use to hang the picture.

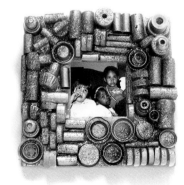

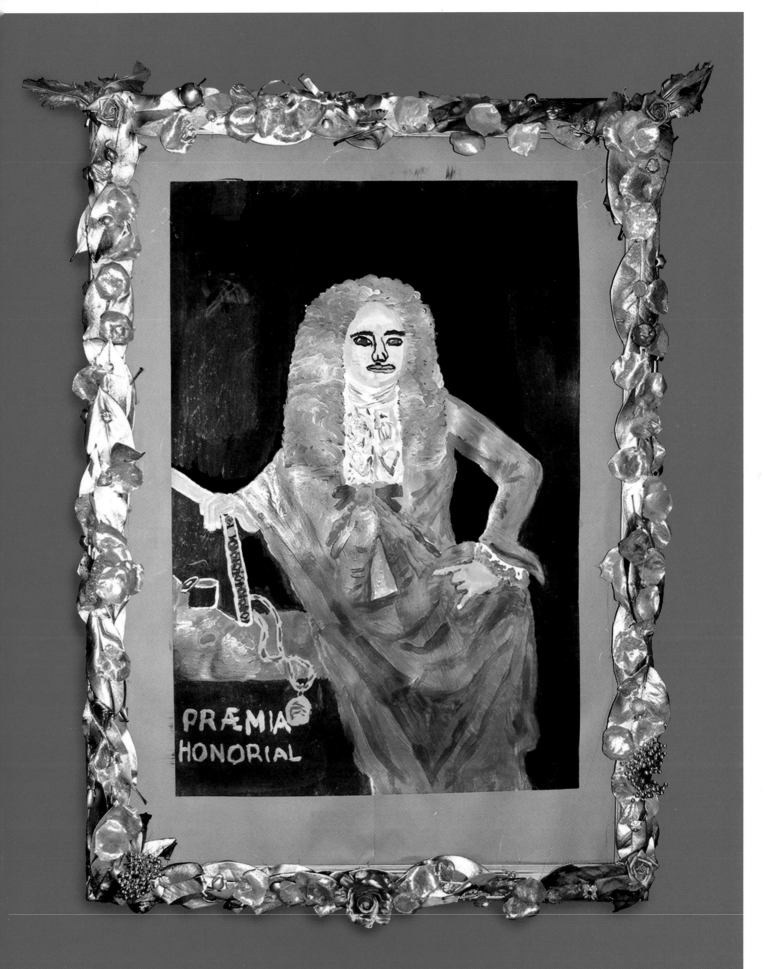

HAND-PAINTED FLOWER

The idea for this project came from the poster designed by the Spanish artist Pablo Picasso for the film *Le Chant des Fleurs*.

What better or simpler shapes are there than your own hands! Draw around them and decorate them to create the petals of this multi-coloured, hand-painted flower – what you might call 'hands on' art.

YOU WILL NEED:

- Paper
- Felt-tip pens or crayons
- Scissors
- Glue
- Paints
- Sponges and brushes
- Buttons, bottletops, beads, especially yellow and green
- Glitter
- A large piece of wood or two medium pieces of card stuck together

Picasso once famously said, "All children are artists. The problem is how to remain an artist once he grows up."

INSTRUCTIONS:

1. Draw the basic flower shape on the wood or cardboard and use as a guide.

2. Draw around your hand and then cut out the shape. You will need lots of these basic hand shapes.

3. Decorate the paper hands using bright crayons, felt-tip pens or paints. Add painted fingernails. Use green colours only for the leaf hands.

4. Use yellow finger-painting to create the centre of the flower on the wood or cardboard. Leave to dry.

5. Use the same techniques for the flower stem: finger-paint the stem green and then stick on green odds and ends.

6. Sponge-paint the background blue for the sky.

7. Now stick the decorated hand shapes around the centre to make your hand-painted flower.

8. For a 3-D feel, choose bits and pieces from your yellow junk box – beads, bottle-tops and buttons – and stick on top. Gold glitter produces a wonderful, shimmering effect.

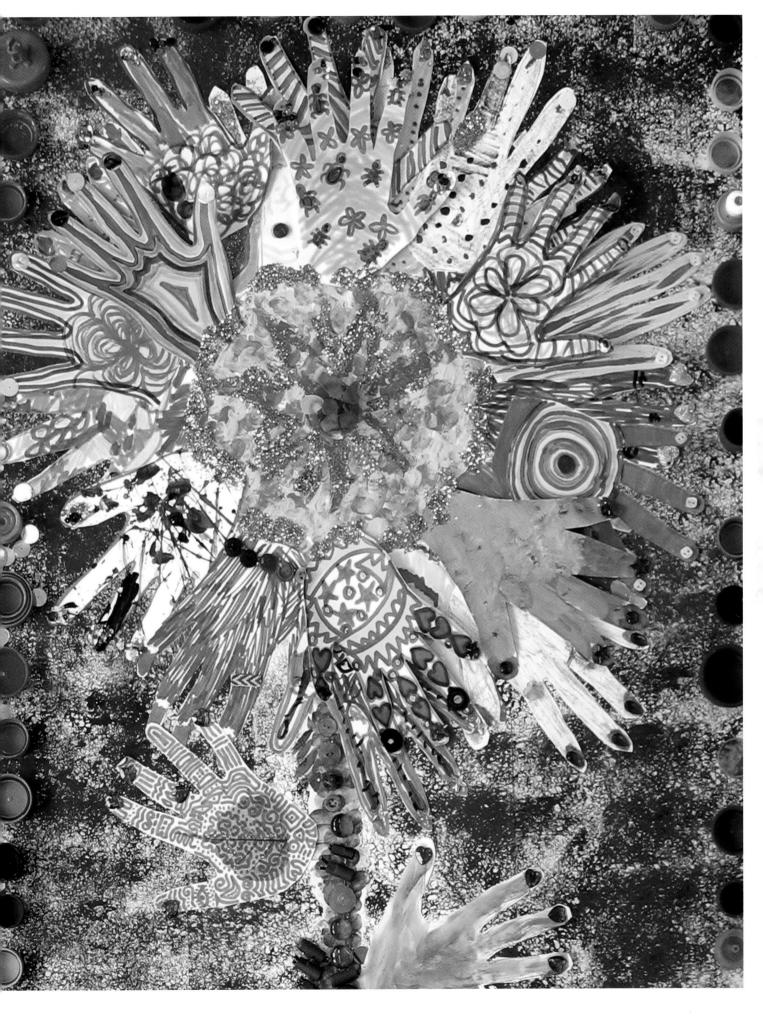

HANDKERCHIEF BUNTING

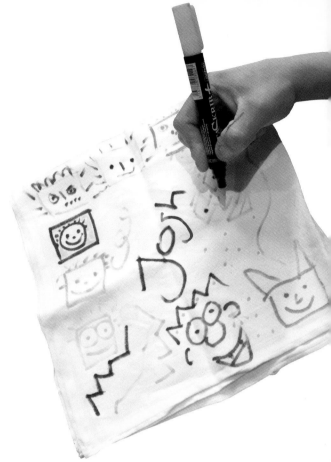

Homemade bunting is great for any kind of celebration. It's quick and easy to make and the results can be stunning. Use fabric – white handkerchiefs or an old sheet cut into different-sized squares, triangles or rectangles – rather than paper, as it is longer-lasting and can be washed and put away to use again. Decorate the fabric with fabric pens – use bold patterns or follow a theme such as flowers, animals, or favourite book characters. All you need now is a party!

YOU WILL NEED:

- ✔ Handkerchiefs or pieces of white material cut into shapes
- ✔ Fabric felt-tip pens
- ✔ String or ribbon
- ✔ Clothes pegs, staples or paperclips

INSTRUCTIONS:

1. Take a handkerchief, or whatever material you are using, and decorate it with your chosen theme.
2. Hang the string where you want it to be.
3. Attach the finished flags with clothes pegs or paperclips.

Handkerchiefs were invented during the reign of Queen Elizabeth I – they were made out of silk and were far too expensive to wipe your nose on. They were hung from the waist, because pockets hadn't yet been invented.

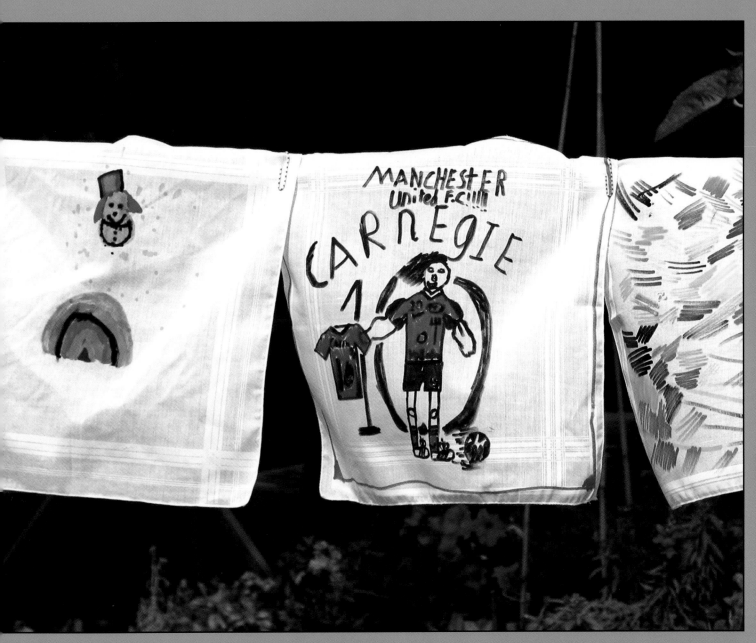

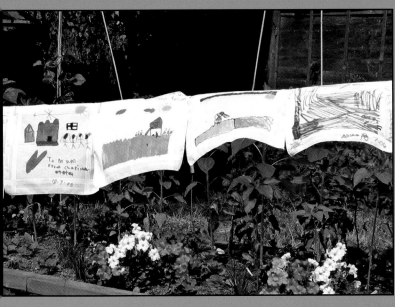

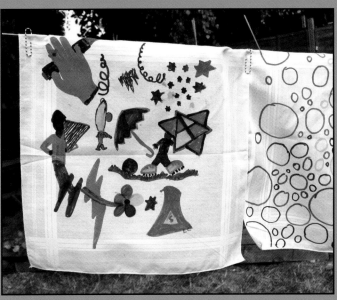

TAKE A CHAIR (AN OLD CHAIR)

These 'statement chairs' by the Spanish designer Marti Guixe are a brilliant example of how easy it is to make something personal.

Try breathing life back into the battered old chair you have in your bedroom. Paint your favourite book character on the seat, add butterfly wings to the back, or create a sumptuous throne fit for a king or queen. Transform it into a tiger, a train or a tropical palm tree. Write a poem, a story or a list of your friends on it. Whatever you do, make it your own.

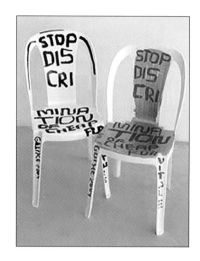

YOU WILL NEED:

- ✔ Old chair
 (see materials page for where to find them)
- ✔ Sandpaper
- ✔ White emulsion paint as an undercoat
- ✔ Coloured acrylic paint
- ✔ Paint brushes
- ✔ Craft glue
- ✔ All kinds of materials, such as gems for thrones, fabric, tags, buttons and ribbons

INSTRUCTIONS:

1. Sand down the chair to give a smooth surface.
2. Wipe down with a damp cloth to remove all the bits you've sanded off.
3. When dry, paint the chair with white emulsion. This creates a blank canvas.
4. When it's dry, paint, stick, create, using the materials you have available.
5. Varnish the chair using diluted craft glue – 1 part water, 2 parts glue.

Don't buy expensive labels, says Marti Guixe – create something yourself. We agree. Add your own label. Go for it!

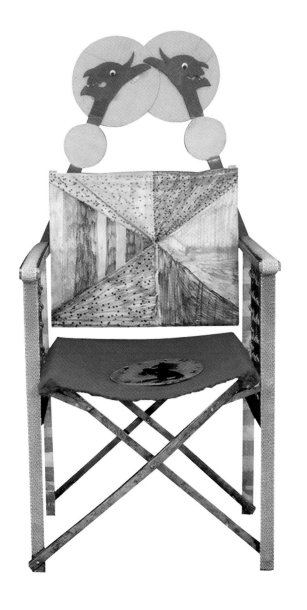
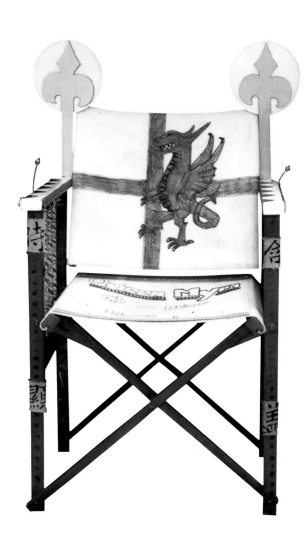
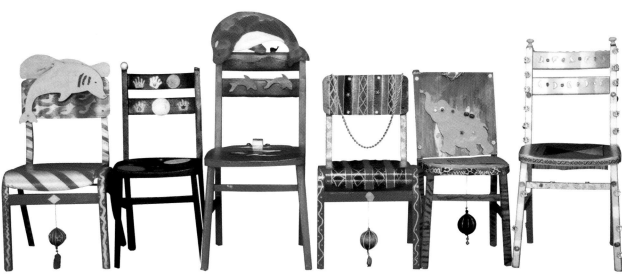

GEOMETRIC FISH

A pile of unused chains, Rawl/wall plugs and screws, and a look at the fish pictures created by the illustrator Korky Paul inspired this project where fish come in all shapes, colours and sizes. First of all, create your fish – you can use stencils or invent your own shape. Then decide on your colour scheme. In our pictures we have used oranges, golds, yellows and blues, but you might prefer a pink-and-purple-spotted colour scheme. To give it a 3D look, add chains, plugs, beads, screws or whatever you have handy that fits with your theme. Then give your fish a name, and hang it up for all to see.

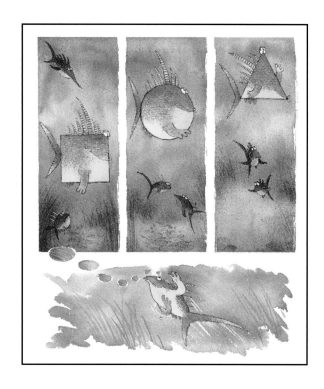

YOU WILL NEED:
- ✔ Painting equipment
- ✔ Glue
- ✔ Good white paper, card, or a piece of wood
- ✔ Basic shaped stencils, made out of card or wood
- ✔ Yellow, cream, orange, gold and blue materials
- ✔ We used old chains, Rawl/wall plugs, screws, corks and beads.

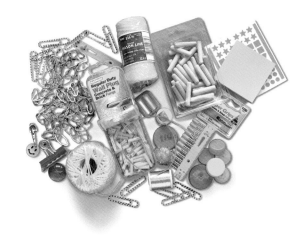

INSTRUCTIONS:
1. Draw around basic-shaped stencils – square, circle, rectangle or triangle.
2. Draw fish details using a basic shape as the body.
3. Paint the background colours.
4. Stick on materials to create 3D geometric fish.

- If you thought fish had no arms, think again – some starfish can have as many as 18!
- Fish have been around for millions of years – they are even older than dinosaurs.

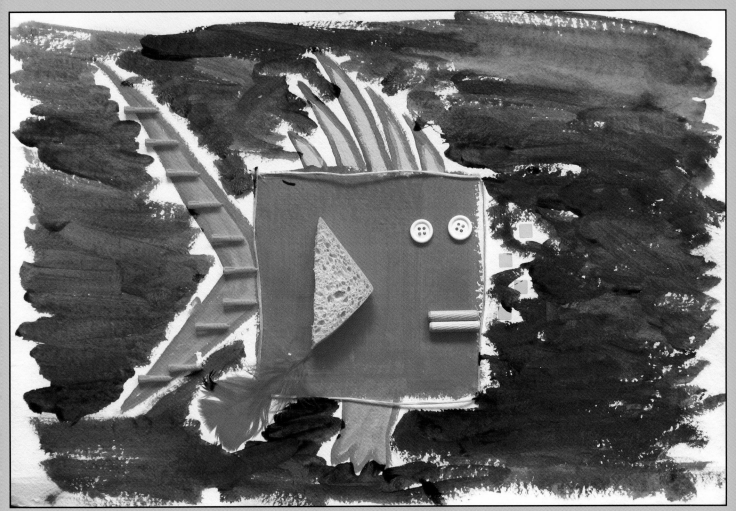

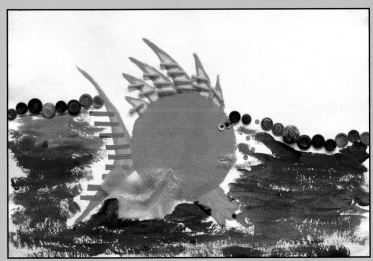

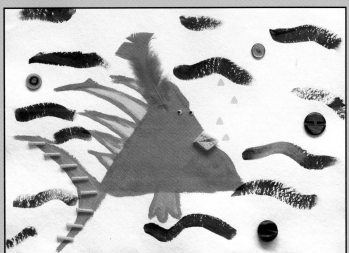

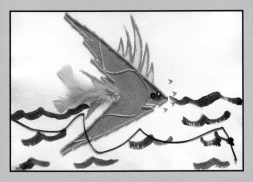

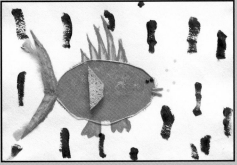

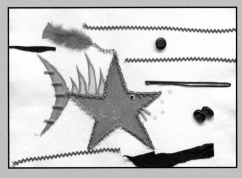

BAGS OF TALENT AND ENVELOPE NAME-PLAQUES

Paper shopping bags and envelopes are easy to come by and can be personalised by writing, painting or sticking your name on the front to make a name-plaque or a "Keep Out" sign for your bedroom door. Or make paper bag portraits, seaside scenes or monster faces using string, ribbons, shells and other items from around the house. Paper shopping bags come complete with handles to hang from clothes pegs, hooks and door knobs, so create your very own art gallery and invite family and friends to come and admire your "Bags of Talent"!

YOU WILL NEED:

- Brown or white paper shopping bags
- Envelopes
- Felt-tip pens and coloured pencils
- Paints and paint brushes
- Glue
- Hole puncher
- Buttons
- String, ribbon and trimmings
- Buckles
- Gems
- Old CDs
- Feathers
- Bottle-tops, shells, and other bits and bobs

INSTRUCTIONS:

1. For envelope name-plaques, punch two holes with a hole puncher at the top of an envelope.
2. Decorate.
3. Paint a name or pick out letters using shells, beads or glitter.
4. String with ribbon to hang up.
5. Hang in a place where everyone can see it!

The Chinese invented paper in AD 105, but they kept their formula a secret. 600 years later, Arabs captured some Chinese papermakers who taught them how to make paper out of bark and rags.

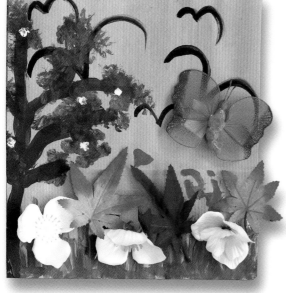

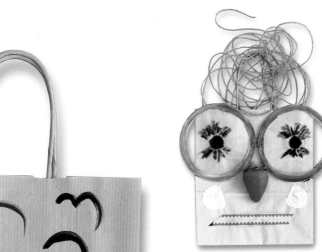

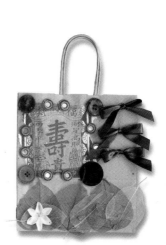

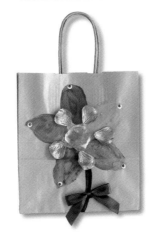

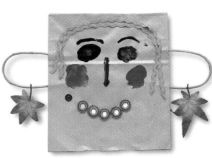

OVER THE RAINBOW

A rainbow is one of the most magical sights in nature. Artists have always enjoyed painting them. Here is one of J.M.W. Turner's famous rainbows.

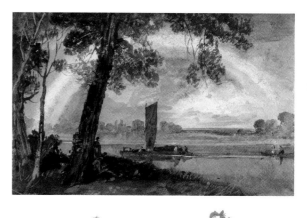

Rainbows are a universal symbol of hope, peace and harmony. So what could be better than to create your own? You will need buttons, beads, Christmas decorations, bottle tops, pen-tops and used wax crayons. Label seven boxes with the colours of the rainbow and start collecting – or paint the rainbow first and stick on the coloured bits and bobs as you come by them. Include an extra box for gold items if you want to add the pot of gold that, according to legend, is found at the end of the rainbow.

YOU WILL NEED:

- ✔ Large piece of wood or 2 pieces of card glued together
- ✔ Paint and brushes
- ✔ Glue
- ✔ Small objects such as buttons, bottle-tops, sequins, ribbon, trimmings, pen tops etc. These should be collected in boxes marked *Red, Orange, Yellow, Green, Blue, Indigo* and *Violet*
- ✔ You may decide to collect a box of gold-coloured items to represent the gold found at the end of the rainbow

INSTRUCTIONS:

1. Paint the rainbow on to your wood or card. Start at the top with red and paint in the right order, orange next, then yellow, green, blue, indigo and violet at the bottom.
2. Match the small objects to the colours and stick them on.
3. Display your rainbow where it will lift the heart of any passer by!

- The colours of the rainbow are formed by the refraction and reflection of the sun's rays on drops of rain.
- One of the easiest ways to remember the order of colours in the rainbow is, "Richard Of York Gave Battle In Vain".

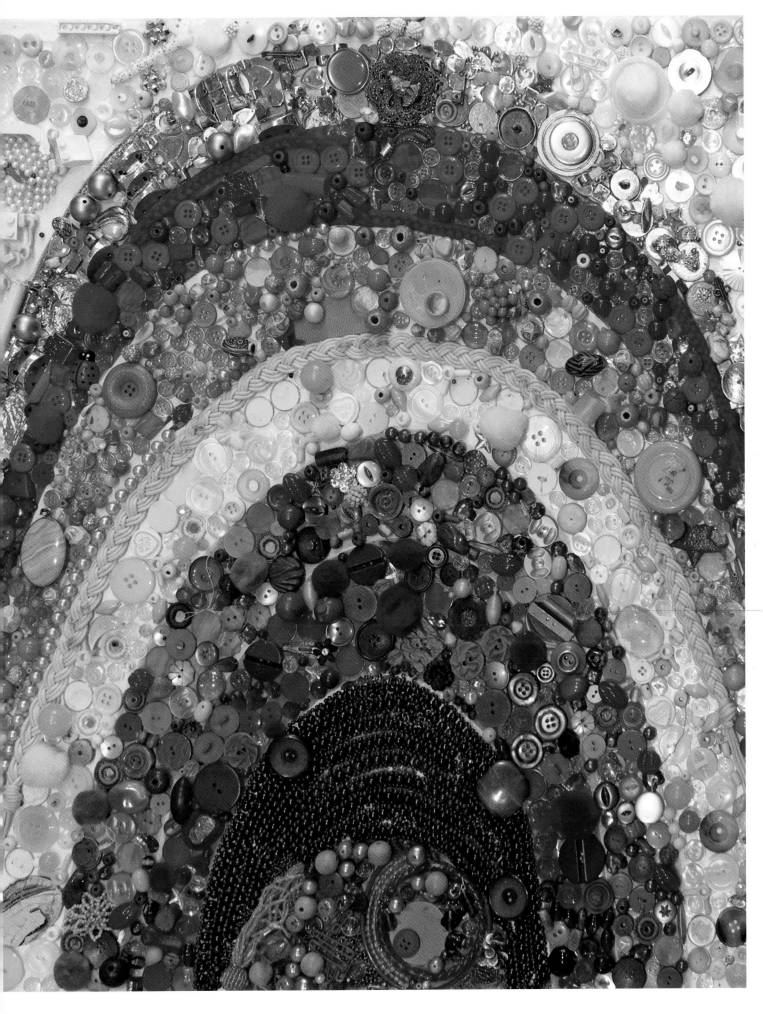

PORTRAIT PLATES

Real ceramic plates are much more satisfying to paint on than paper plates. They don't crumple or bend and will last forever. Collect white plates from jumble sales and junk shops and then paint a portrait of yourself, a friend or member of your family. Fit each plate with a plate hanger, and hang it up for everyone to see.

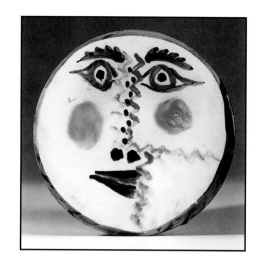

YOU WILL NEED:

- ✔ White ceramic plates
- ✔ Acrylic paints
- ✔ Brushes
- ✔ Gems, googly eyes, buttons, feathers
- ✔ Braid and wool for hair
- ✔ Glue
- ✔ Spray varnish (to be used by adults only)
- ✔ Plate hangers

Pablo Picasso painted lots of self-portraits during his life, each one matching his current style of painting. He also painted thousands of ceramics between 1947 and 1971 at the Madoura pottery workshops in Southern France.

INSTRUCTIONS:

1. Look in a mirror or use a photograph to decide how you want to paint your portrait. Remember, it doesn't have to be a mirror image, but it should tell you something about the person.
2. Using a black felt-tip, draw the basic features on to the plate.
3. Paint the plate-portrait using acrylic paints.
4. Add fabric, feathers, buttons and braid for a 3D effect.
5. Spray varnish – adults only – to "hold" the paint.
6. Fit a plate hanger on to the plate.
7. Hang up.

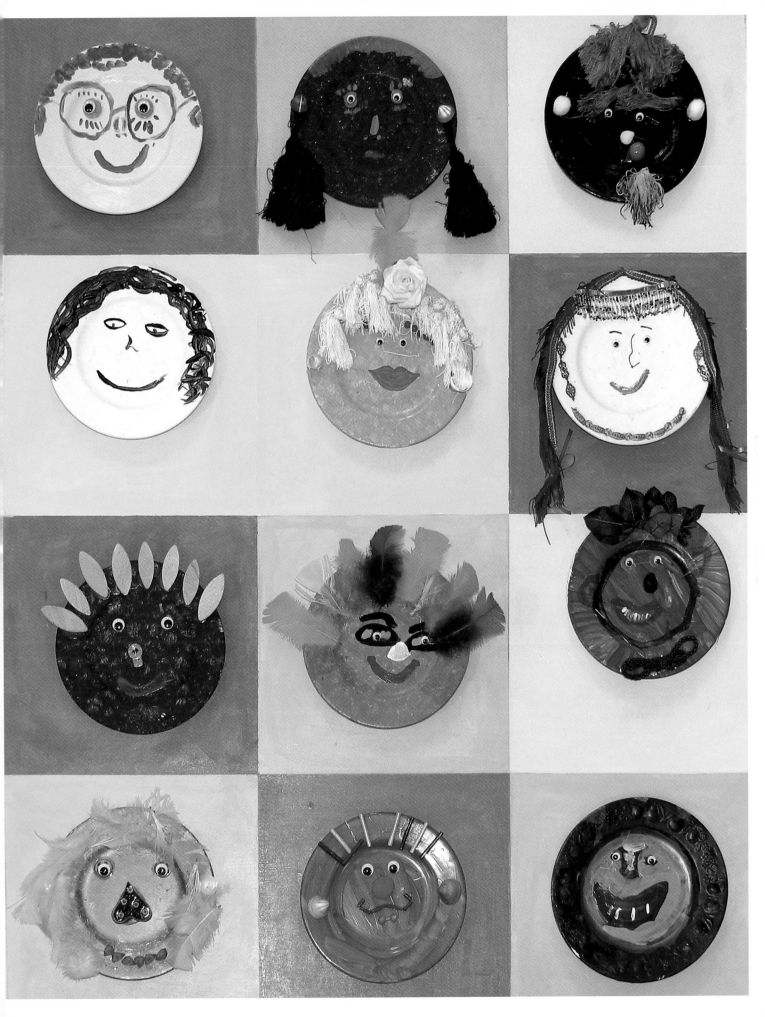

BOTTLE PEOPLE

Take any plastic bottle – they all have natural shoulders, some even have arms – and transform it into a person or animal of your dreams. Princess or pop star, musician or magician, snowman or scarecrow, choose anything you fancy. You could even make the characters from your favourite book and use the bottle puppets to act out the story.

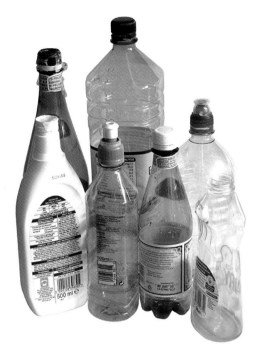

YOU WILL NEED:

- ✔ Plastic bottles of all shapes and sizes
- ✔ Plastic detergent balls, wooden spoons stuck into the necks of the bottles, or polystyrene balls for heads
- ✔ Fabric for clothes
- ✔ Wool, braid or raffia for hair
- ✔ Googly eyes, buttons or beads for eyes
- ✔ Ribbons and trimmings
- ✔ Pipe cleaners
- ✔ Tassles and feathers
- ✔ Paperclips, stars or gems for ear rings
- ✔ Felt tips
- ✔ Glue and sellotape/Scotch tape
- ✔ Scissors

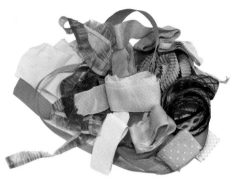

INSTRUCTIONS:

1. Choose a bottle to use as the main body.
2. Attach a head, using polystyrene balls, plastic detergent balls or wooden spoons.
3. Draw the face or stick on buttons and beads.
4. Add hair using braid or wool or make a feather hat.
5. Pipe cleaners make good arms.
6. Dress your bottle person using fabrics and trimmings.
7. Make an exhibition of all your bottle people.

An average household uses 375 plastic bottles a year. Some are recycled to make traffic cones, park benches, and even clothes. Now they can also be transformed into bottle people!

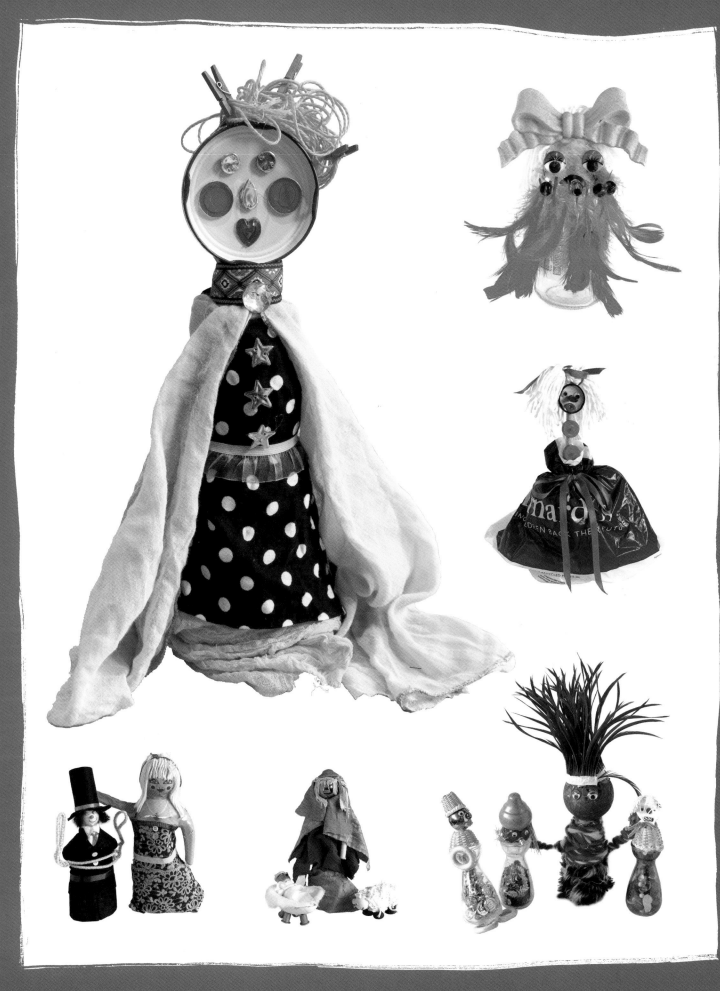

MAKING YOUR STAMP

Stamp collecting, or *philately,* as collectors call it, has fascinated generations of children and adults. The colours, the pictures, the mystery of stamps from foreign lands make them instantly appealing. They are also great for decorating anything from boxes to book covers, lampshades to rubbish/trash bins. Here's how to decorate a chair, but a table or almost anything will do.

YOU WILL NEED:
- ✔ Lots of stamps of all colours
- ✔ Craft glue and brushes
- ✔ Chair – the one opposite came from a junk shop

INSTRUCTIONS:
1. Sand down the chair so that all the surfaces are smooth.
2. Wipe off the wood-dust with a damp cloth to remove all residue, then leave to dry.
3. Paste on stamps using diluted craft glue – 1 part water, 2 parts glue. Then paint over the entire surface with a layer of diluted glue. This will give the table a varnished look.

- China issued the largest stamp in history. It measured 21cm by 6.5cm.
- Bhutan released a stamp in 1973 which looked like a record and played the Bhutan National Anthem!
- The Keeper of the Royal Philatelic Collection's only job is to look after Queen Elizabeth II's stamp collection.

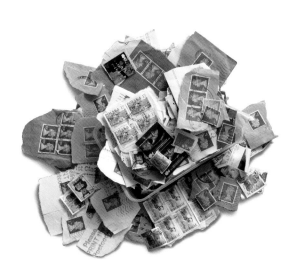

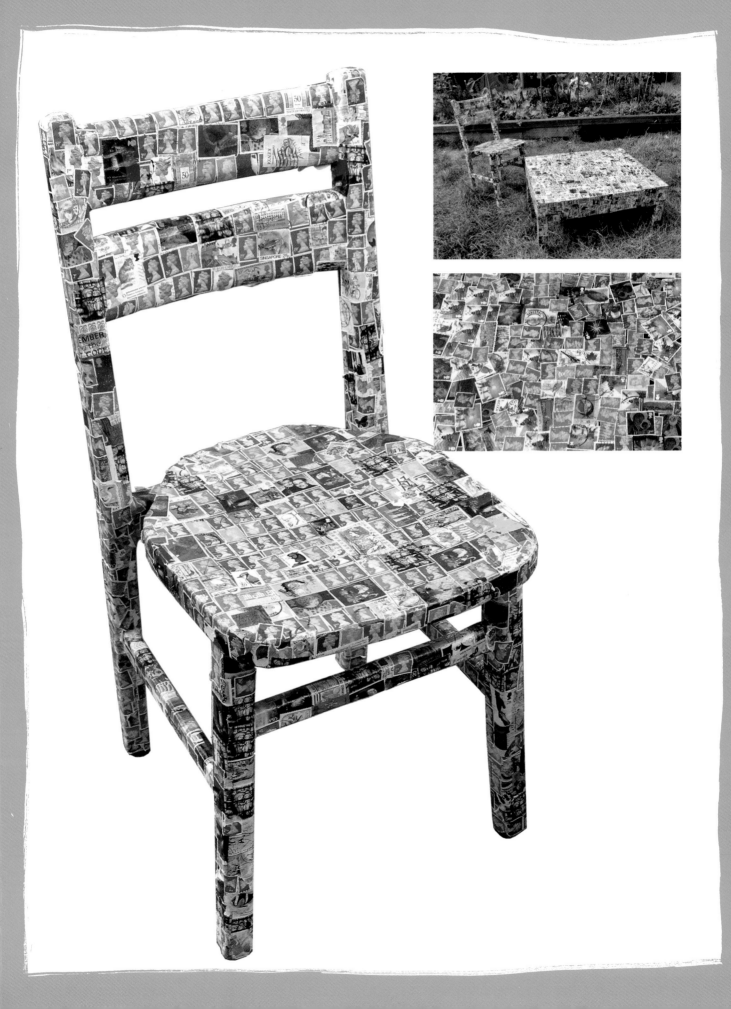

THE OWL AND THE PUSSYCAT PUPPET SHOW

Edward Lear's famous poem *The Owl and the Pussycat* inspired this puppet show, but any favourite story or poem will do.

The characters are made from kitchen utensils. The theatre is an old bathroom cupboard with its back removed, or you could use a cardboard box. Be as creative as you like with the scenery.

For this project you need a group of friends – to make the puppets and to perform the show. Then invite an audience to watch it.

YOU WILL NEED:

- ✔ Wooden spoons, spatulas and mops
- ✔ Feathers
- ✔ Fake money
- ✔ Plastic flowers
- ✔ Fabric
- ✔ Buttons
- ✔ Paint, paper and brushes
- ✔ Glue
- ✔ Scissors
- ✔ An old cupboard or box with the back cut out

INSTRUCTIONS:

1. Make each character out of a kitchen utensil. Decorate the utensil to look like the character.
2. Draw and cut out props.
3. Make the theatre by knocking the back out of an old cupboard, or use a cardboard box.
4. Paint the scenery on paper larger in size than the box or cabinet you are using for the theatre. You will need to paint three scenes: the sea with stars above, the land with Bong-trees, and the beach with a moon above.
5. Slot the scenery in behind the cupboard or box and change it for each scene. Then perform the show!

Edward Lear was a 19th-century artist. He taught Queen Victoria how to paint. But he was better known for writing nonsense poetry. What do you think a 'runcible spoon' is?

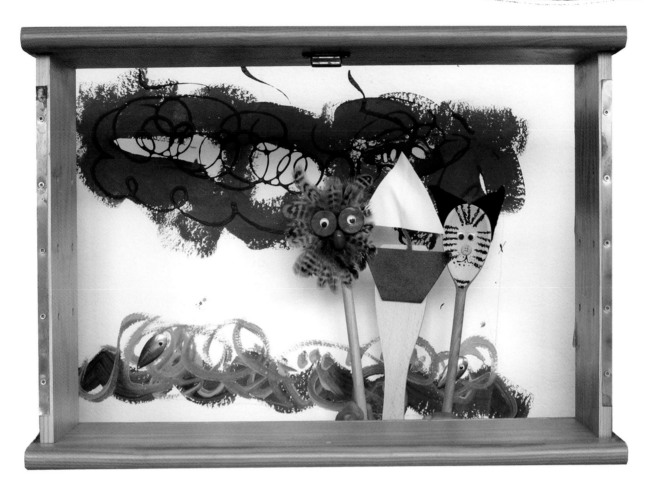

The Owl and the Pussy-cat went to sea
In a beautiful pea green boat,
They took some honey, and plenty of money,
Wrapped up in a five pound note.
The Owl looked up to the stars above,
And sang to a small guitar,
'O lovely Pussy! O Pussy my love,
What a beautiful Pussy you are,
You are,
You are!
What a beautiful Pussy you are!'

Pussy said to the Owl, 'You elegant fowl!
How charmingly sweet you sing!
O let us be married! too long we have tarried:
But what shall we do for a ring?'
They sailed away, for a year and a day,
To the land where the Bong-tree grows
And there in a wood a Piggy-wig stood
With a ring at the end of his nose,
His nose,
His nose,
With a ring at the end of his nose.

'Dear pig, are you willing to sell for one shilling
Your ring?' Said the Piggy, 'I will.'
So they took it away, and were married next day
By the Turkey who lives on the hill.
They dined on mince, and slices of quince,
Which they ate with a runcible spoon;
And hand in hand, on the edge of the sand,
They danced by the light of the moon,
The moon,
The moon,
They danced by the light of the moon.

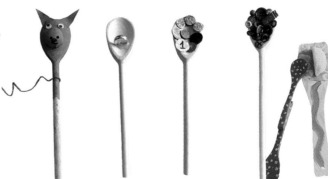

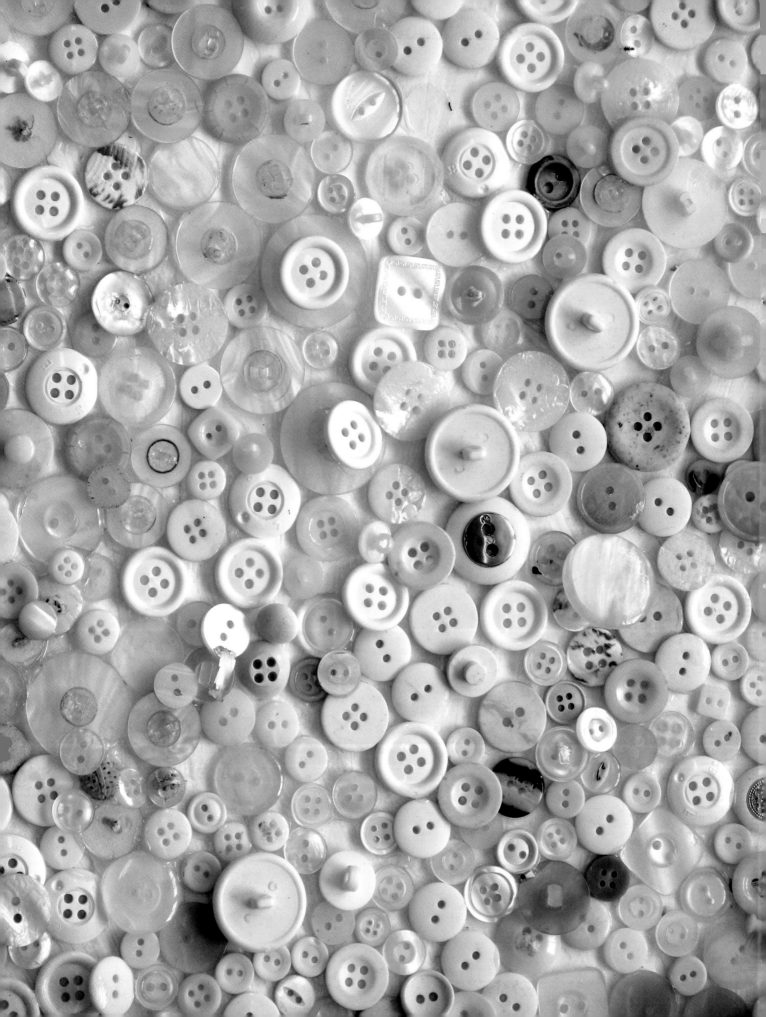